BLACK $ WATER

BABYLON

MICHAEL KNOWLTON

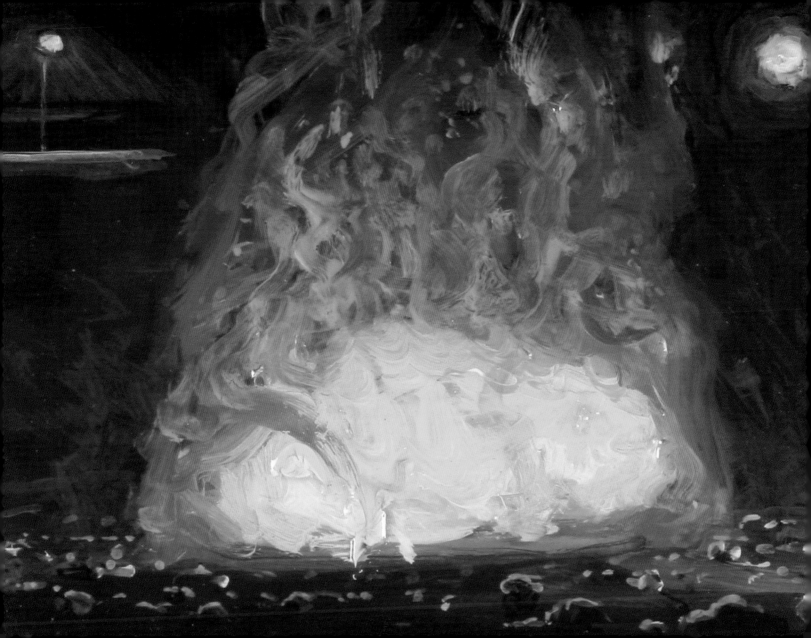

Dedicated to Buzz, with love - MK

GRAND CENTRAL PRESS
SANTA ANA, CALIFORNIA

GUNPOINT KIDS
Oil on panel 5 ½" x 6 ½"
"When they set up the Mission Accomplished spot, they needed to make sure the banner was facing the harbor so it could be shot with the open sea behind it." - MK

Caustic Redress:
The Rising Tide of Visual Essayist Michael Knowlton
Nathan Spoor

A true war story is never moral. It does not instruct, nor encourage virtue, nor suggest models of proper behavior, nor restrain men from doing the things men have always done. If a story seems moral, do not believe it. If at the end of a war story, you feel uplifted or if you feel some small bit of rectitude from the larger waste, then you have been made the victim of a very old and terrible lie. There is no rectitude whatsoever. There is no virtue. As a rule of thumb, therefore, you can tell a true war story by its absolute and uncompromising allegiance to obscenity and evil.
— *Tim O'Brien*

I believe in compulsory cannibalism. If people were forced to eat what they killed there would be no more war.
— *Abbie Hoffman*

It is a time when current artistic trends would have one believing that the postnuclear world is in a state of pluralist fluff worship. It is also a day and age when consumerist propaganda is the mass drug of choice, leaving entire demographics of the Americas in a vacant wake of better cleansers and the inevitable boredom of political white-washings. But it is also the moment when a critical eye, a tried and true heart, and an expressive hand can capture a moment in as trusting a hold as any vexed tongue. Political realist and satirist Michael Knowlton captures the essence of this contemporary landscape.

In 1965, the budding sociopolitical visual spokesman was fifteen years old. Michael's father, then a colonel in the Air Force Reserves, was called upon to travel to the staging grounds of the conflict in Vietnam. His experience in Vietnam provoked a profound change in his outlook which, not surprisingly, provoked many family dinner discussions. At this point, the conflict in Southeast Asia had still to escalate fully, when it would captivate the attention of the mass media. But when it did, it would leave a lasting impression upon the mind of the then college-bound Michael, whose mother took to the streets to protest the war.

As the artist Jack Levine did before him, Knowlton employs ample doses of political and social satire to plant the seeds

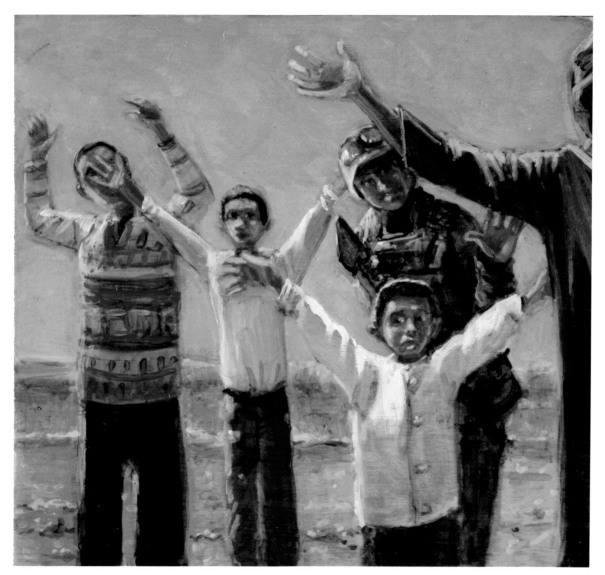

"Our 'neo-conservatives' are neither new nor conservative, but old as Babylon and evil as hell."

Edward Abby

TIME OUT
Oil on panel 9" x 12 ½"
"When words won't do, sign language will hopefully buy a moment." - MK

of doubt in his audience. Whereas Levine's expressive lampoons deliver their commentary through exaggeration, Knowlton relies principally on observations made through the eyes of an unflinching documentarian. His is a life of savage returns, a further commentary on the effect of excess on a land of long-standing tradition. One work that exemplifies the artist's appetite for portraying the underbelly of political drama is the epic Vegas Holiday (2004). In this moment of debauchery, the viewer is treated to a peek into the lost weekend of a mercenary and his associates. Knowlton was inspired to create this work, the first in the Blackwater Babylon series, by first-hand reports from Iraq by actor Sean Penn as printed in the San Francisco Chronicle. "The articles were very powerful," said Knowlton. "Sean Penn visited Iraq before the United States began the occupation, and talked to the people there. One of the most prominent things that he noticed was the amount of private security thugs in the area. They weren't Army or military at all. They were corporate thugs, and without any law in the land, these guys were just going around harassing people for their papers and bullying people around." Situated throughout the painting are the mercenaries and their counterparts, the corporate tycoons, as well their female companions in various states of opulent abandon. In the face of global affliction, this image submits to us a new vision of corporate and cultural decay.

This painting's mercenary aspect is a loving homage to the work of Leon Golub. The other paintings in the series provide the viewer with a visit to the land of Babylon through a less explicit narrative. Knowlton deftly creates his own visual means of reporting aggressive and violent oppression. "Rather than show bodies everywhere, like Goya, I wanted to portray moments of daily life in war, showing the small events that happen in between the headlines. The message could be related without over-sensationalizing it," he states. "I painted these works in order to have a vote. I just wanted to have a voice somehow."

These works by Knowlton exemplify one individual artist's quest to come to terms with public life in contemporary society. There is an inherent, as well as globally and morally relevant, need for art of this nature. In this age of artistic pluralism and political carnage, art strives to find truth. There must be paintings about the dance as well as the terrors of war. There must be someone defending morality in the name of the oppressed, the unheard, and the unseen.

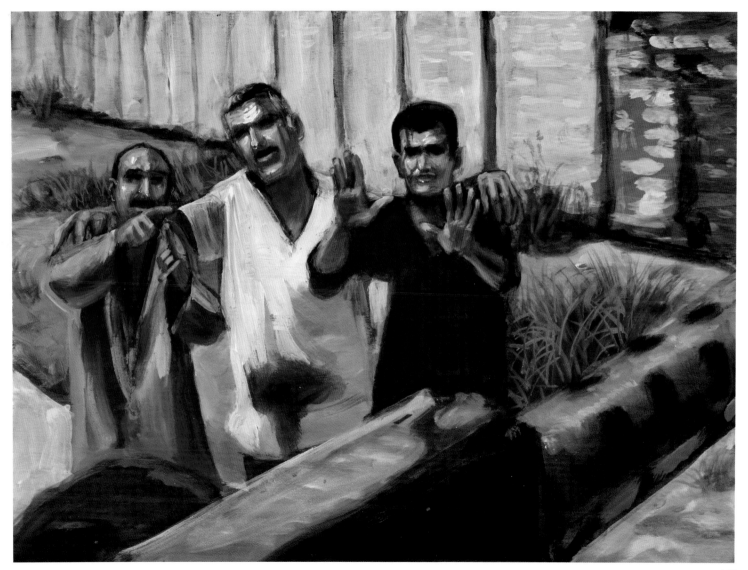

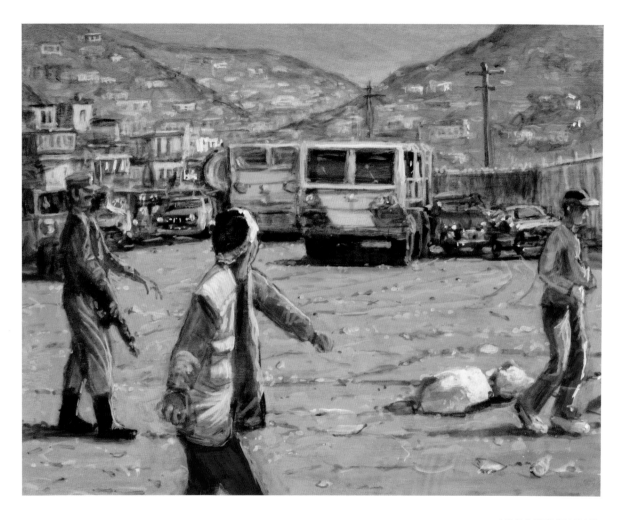

HUMVEE-KABUL
Oil on panel 7" x 9"
"Not everybody likes the candy and cigarettes they give out. Once again, stones and tanks." -MK

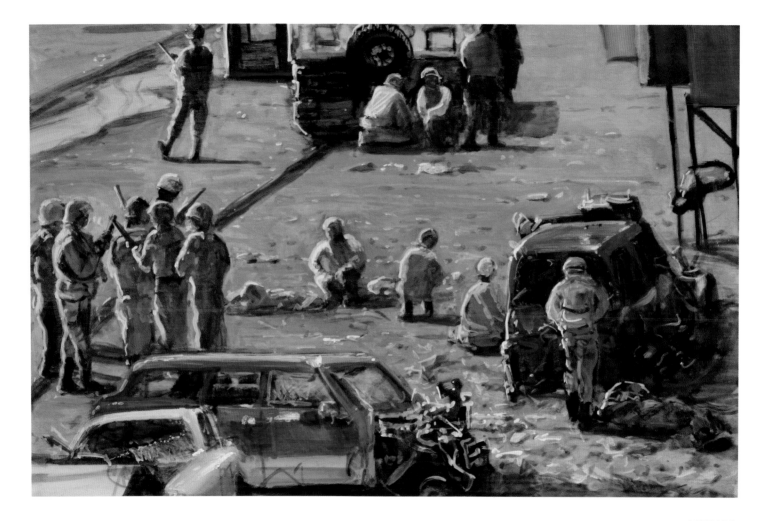

MEDICS
Oil on panel 8" x 12"
"As it was Viet Nam, in Iraq troops are having a hard time determining exactly who the enemy is, alive or dead." -MK

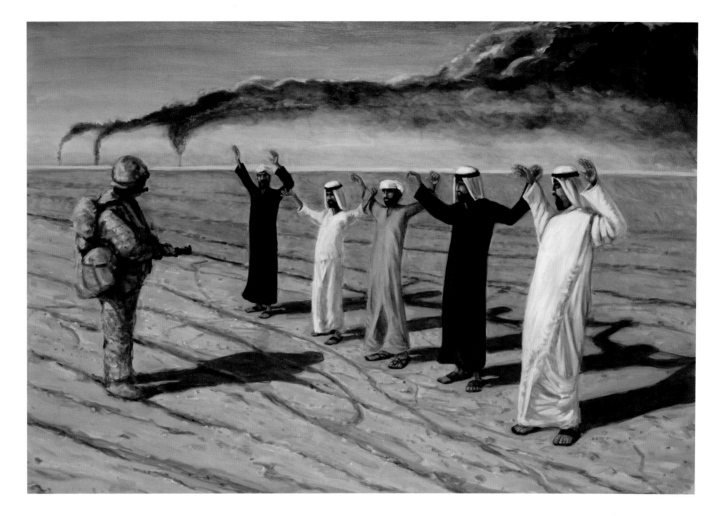

GUNPOINT #3
Oil on linen 36" x 52"

"In Viet Nam, we faced an enemy in black PJs and sandals. In the desert we're still overdressed for the party. Oil burning in the distance makes time pass like an hour-glass with a big middle hole." - MK

"The conquest of the earth, which mostly means the taking it away from those who have a different complexion or slightly flatter noses than ourselves, is not a pretty thing when you look into it too much."
Joseph Conrad

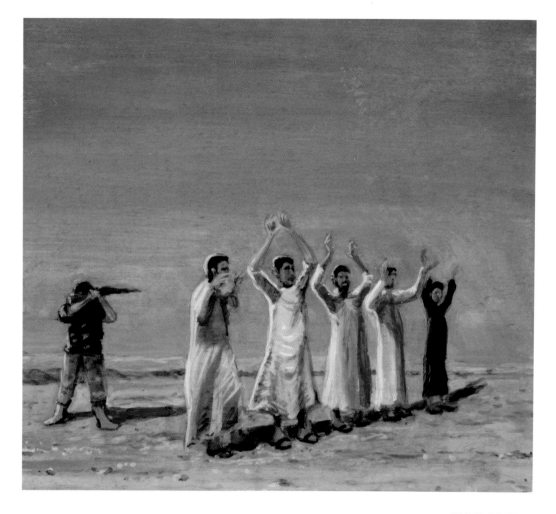

GUNPOINT #2
Oil on panel 5 ½" x 6 ¼"
"Ambrose Bierce said that war is 'God's way of teaching Americans geography.'" - MK

"As for myself, I walk abroad o' nights and kill sick people groaning under walls: Sometimes I go about and poison wells."

Christopher Marlowe

Michael Knowlton's Blackwater Babylon Series
A Breif Commentary
C.R. Stecyk

Aesthetic judgments require winners as well as losers. Crusaders and jihadists alike disappear into the oblivion of the unrelenting sands of despair where Michael Knowlton willingly stalks. Chillin with the villains and coming up zero with the heroes, this painter muses on the privatization of mayhem with a Jesuit's allegorical missionary zeal. He fumes over the desecration of Mecca using spectacular kinds of illusion that harken to Moslem artists' avoidance of naturalistic representation and their mastery of stylized abstraction. Mesopotamia never looked more unsettling than in Knowlton's characteristic impasto-highlighted ziggurats and his infinite horizons of glazed spatial tones, smoke, and fumes. Knowlton enjoys embarking on these pilgrimages of risk that he undertakes enroute to wry social criticism.

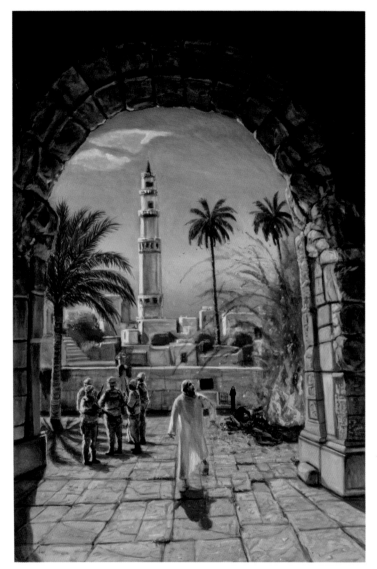

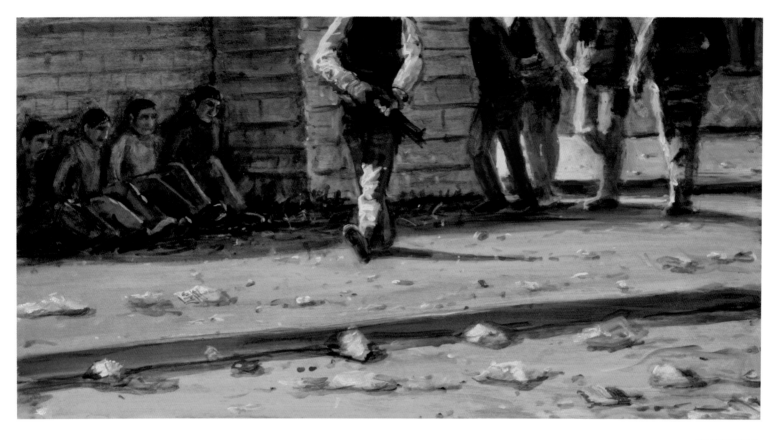

ARCH - KABUL
Oil on linen 51" x 34"
*"Humpty sat on a wall, tried to make a call, but
a lady's scream cut through wide and tall." - MK*

THE WALL
Oil on panel 6 ½" x 12"
*"A wall is a structure that divides space,
casting shadow and shade, stopping
wind, keeping man and animal
on one or another side. People cry on
walls, pray to them, are shot on them
or lean on them with nylon handcuffs
in a row, sitting in garbage." - MK*

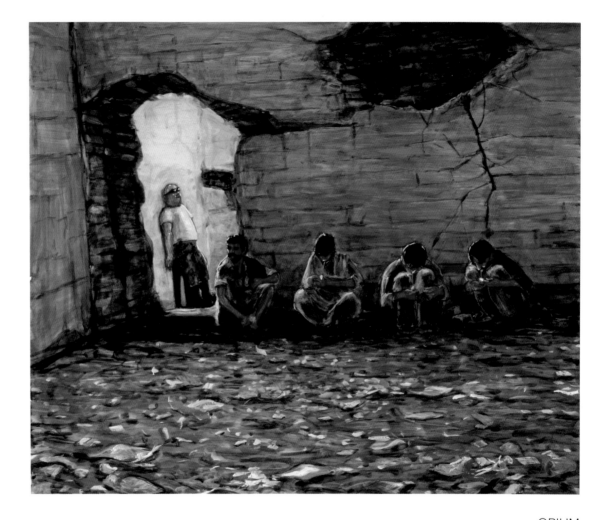

OPIUM
Oil on panel 17" x 20"
"A Viet Nam vet once told me that the farther you got from central command the farther you got from law and things became surreal, other worldly." - MK

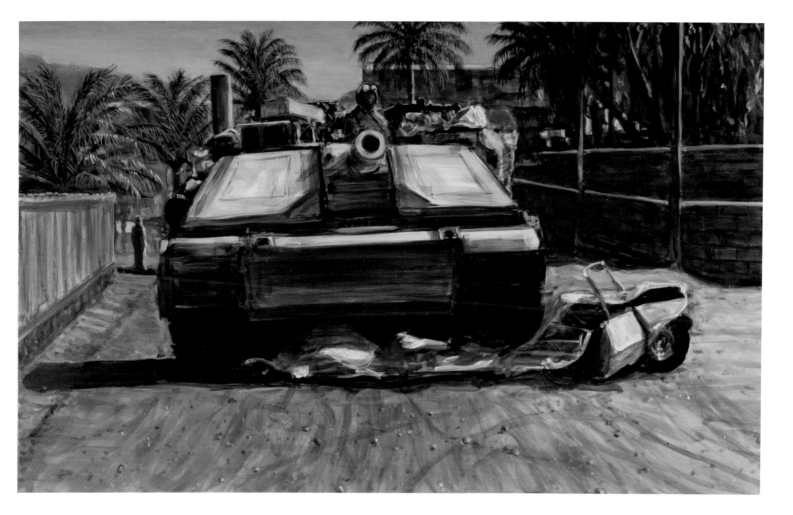

TANK AND CAR
Oil on panel 14" x 23"

"If we hadn't been at war, our National Guard might have helped in New Orleans and lots of lives might have been saved. If we go on invading other countries, where will our soldiers and tanks, planes and bombs come from? How many countries can we build bases on before we run out of resources and excuses?" - MK

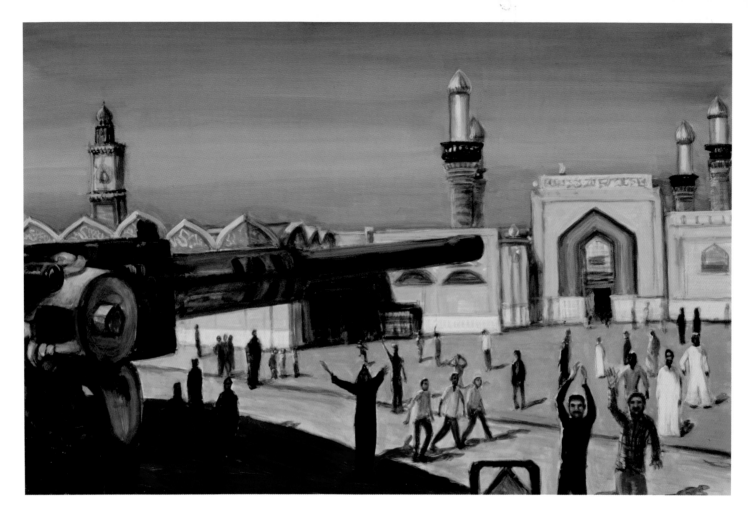

MOSQUE
Oil on panel 15" x 23"
"A painter friend once told me, 'Anyone who will die for their religion will kill for it.'" - MK

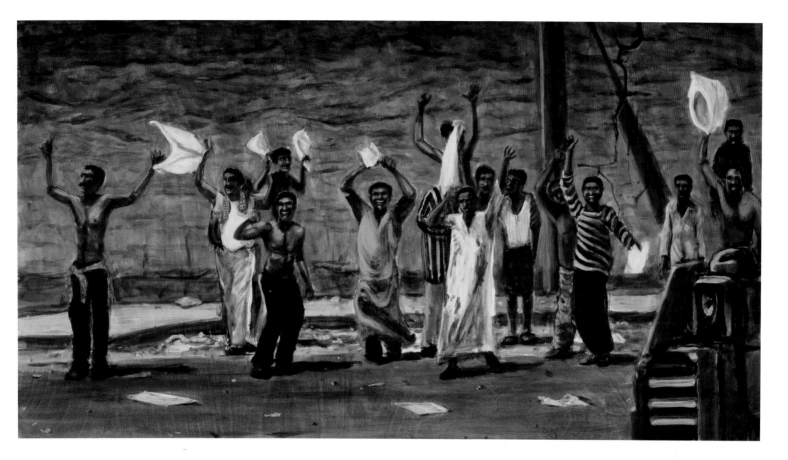

STREET PASSING
Oil on panel 11 ½" x 21"
"George Herbert Walker Bush spoke of 'kicking the Viet Nam Syndrome once and for all.' What kind of country needs to prove to them selves they are war winners? Today there is a new definition for 'Viet Nam Syndrome'" - MK

" *You can no more win a war than you can win an earthquake.*"

Jeanette Rankin
first female member of congress

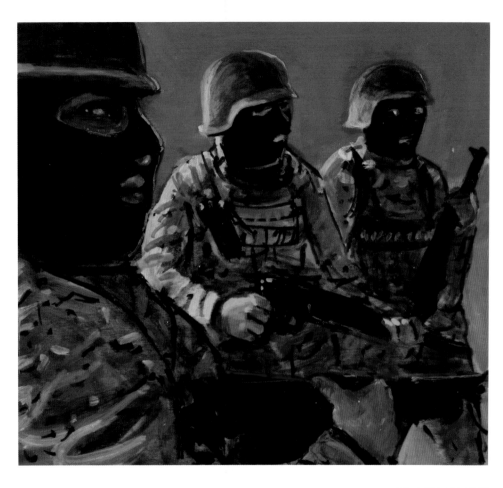

BLACK MASKS
Oil on panel 5" x 5"
"*I saw a video taken from the rear window of a private contractor's vehicle as it sped down the road passing cars and randomly firing at them. Two or three of the cars crashed, the drivers wounded or dead. The audio track had laughing.*" - MK

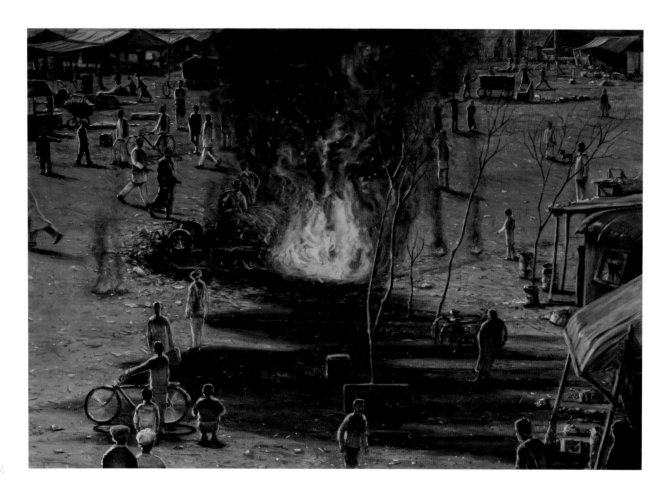

FIRE - KABUL
Oil on linen 54" x 77"

"I'd read about the Taliban and how they destroyed the sandstone Buddhas but invading Afghanistan to smoke out a handful of Saudis didn't make sense. Hadn't that been a big mistake of Russia's? I spoke with a Russian woman and she told me, 'We lost so many boys there.' Car bombs occur often in Kabul." - MK

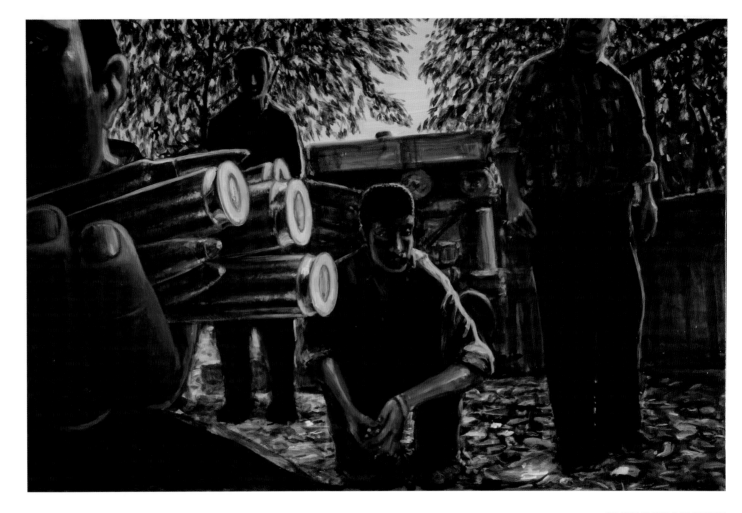

OUTDOOR MARKET
Oil on panel 14" x 23"
"The President has kept one campaign promise. He said he would unite people." - MK

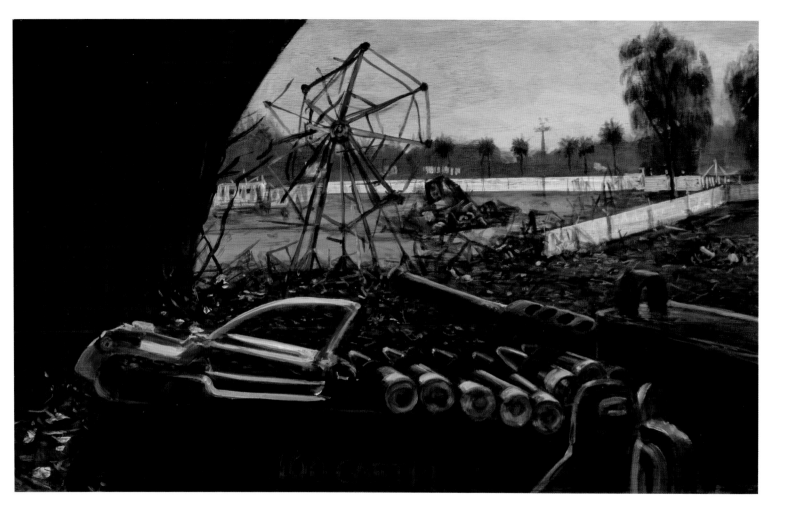

FERRIS WHEEL
Oil on panel 12" x 20"

"A speck of U238 can cause cancer. The Pentagon admits to firing 320 tons of Depleted Uranium into farms and neighborhoods during Desert Storm. Before "Shock and Awe". 4.5 million year half life. One half of Iraq is under fifteen years old." - MK

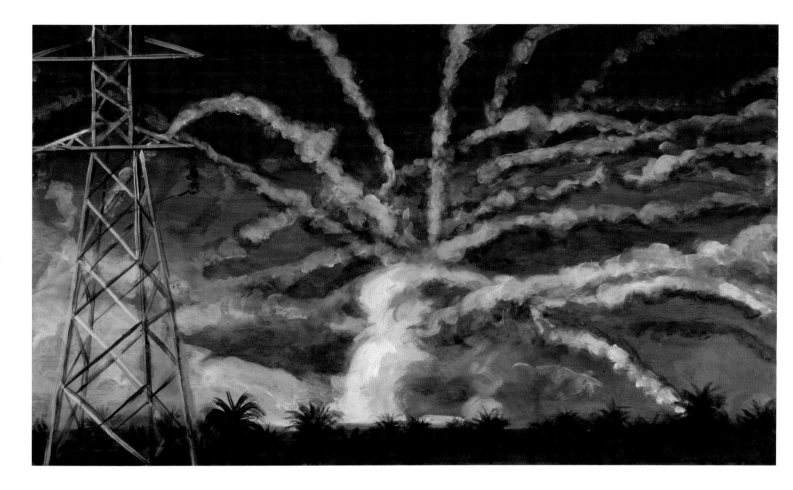

FIRE FIGHT
Oil on panel 9" x 16"
"I read the other day that the Iraq Afghanistan war will cost us over three trillion dollars. Bush talks of decades of occupation. How does bouncing rubble of depleted uranium make us safer? What does that expenditure mean to our infrastructure? Whatdoes it mean to the Euphrates River?" - MK

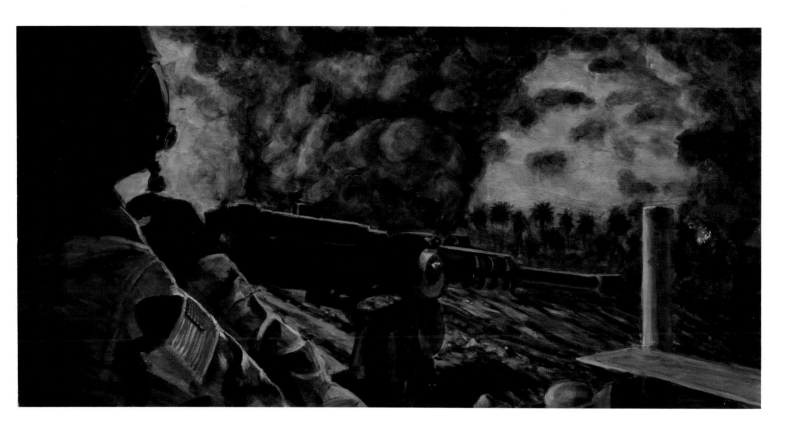

BURNING PALM
Oil on panel 14" x 24"
"In 1965, my dad, who retired a Brigadier General in the Air Force reserves, went to Viet Nam for a short time. I remember him saying at the time, "No son of mine is going to go there. We have no business there." - MK

On Michael Knowlton's Blackwater Babylon Series
Jerome Witkin

Michael Knowlton is protesting a dirty and seemingly endless war. While so much of contemporary painting offers a tongue-in-cheek approach to irony, Mr. Knowlton, in the tradition of Francisco Goya, Honoré Daumier, Leon Golub, Kathë Kollowitz, and George Grosz, is pointing a sharp finger at man's capacity to hurt and destroy.

These recent works, like his previous Life in Los Angeles series, manipulate photo sources and reassemble them into a place of theatre and largesse. This group includes two large summarizations of this current Iraq war. The best of these two is Sermon (2004.). Knowlton, who is becoming a master of human gesture, here confronts us with a large man, his arms raised. At first, his is a gesture of surrender, or perhaps the gesture of hopelessness of all wars victims. No! Horribly, he becomes a propagandist for the current Bush administration, here declaring this farcical and forced war to be necessary. This large and disturbing figure, the one-eyed man in the land of the blind, is madly and joyously celebrating the ongoing destruction of a society in

[continued on pg. 28]

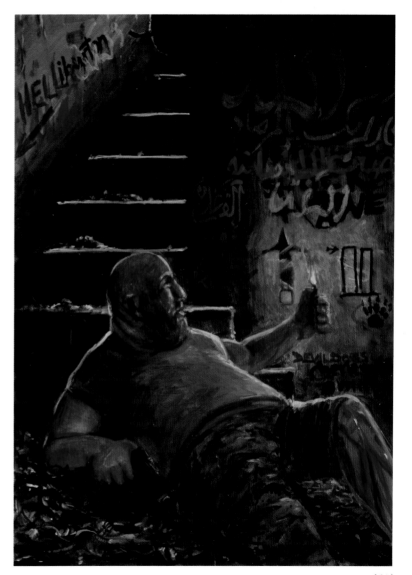

HELLIBURTON

Oil on panel 10" x 8"

"One of the last things Dick Cheney did as Secretary of Defense under George H.W. Bush was to commission a study on how to privatize the military bureaucracy. Blackwater, Caci, Carlyle, and Halliburton all help today in our war effort. A look at the corporate heads reveals the usual Oval Office suspects. The fight for turf is expressed in pissing on your corners, painting over the enemy tags, taunting, threatening and rewriting history." - MK

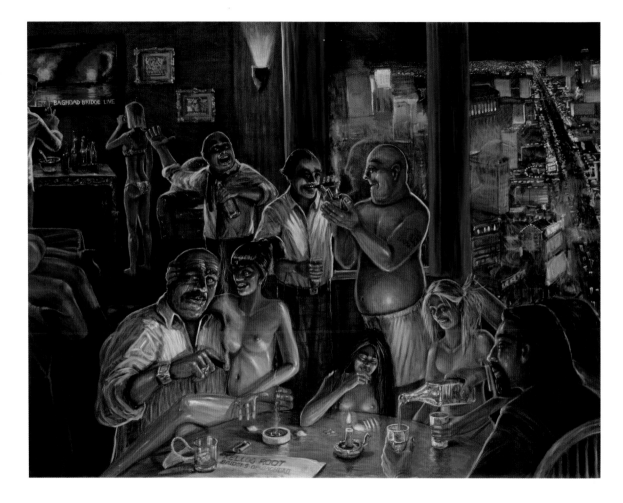

VEGAS HOLIDAY

Oil on linen 57" x 76"

"This was the first painting of the series. I wanted to show mercenaries and corporate heads on vacation in Vegas. Coked out, they all lie, cry, and jabber at once. On CNN, a bridge in Baghdad has been destroyed. On the table is a blueprint for Bridges of Baghdad, which says on it, 'Kellogg Root'." - MK

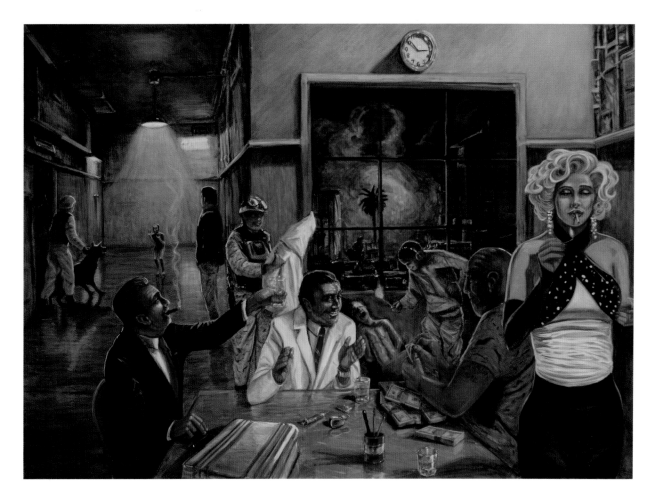

BUSINESS MEETING
Oil on linen 57" x 78"
*"I heard that they were playing catch
with shrink-wrapped blocks of hundreds,
a million dollar game of catch."* - MK

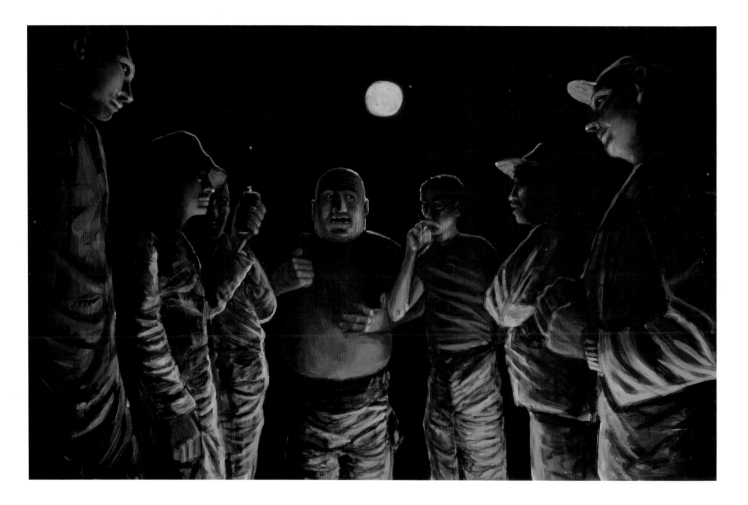

FULL MOON
Oil on panel 14" x 22"

"Back in the days of John Wayne, there was a respect for honesty. 'OK, you won the election fair and square. I'll let you have your shot. It's the American way. The system that works'. Then somewhere along the line guys like Rove set the standard for a new morality. If Jesus came back today, Carl Rove is the first person he'd beat the shit out of." - MK

THE SERMON
Oil on canvas 51" x 120"

"Could it be, that we've bombed a country to the stone age twice in a decade, forever fouled their soil, crippled their utilities, killed and maimed thousands, torn our own country apart, blackmailed and threatened reluctant countries into complicity, just to make money for a few shareholders?" - MK

[continued from pg. 24]

the promise of some perfect future. Knowlton pushes the paint and pyrotechnics and offers us a view of a Hell on Earth, with this American Devil welcoming the locals to their present and future landscape. This is Knowlton's most disturbing and most potent piece. In Humvee, Kabul, his space compresses and disturbs. In Medics and Time Out, he continues to play with gestures and stress in the figures. Unlike the previous cool of the Los Angeles images, now Michael Knowlton's heat crowns this work with purpose and a plea for sanity and discourse between societies.

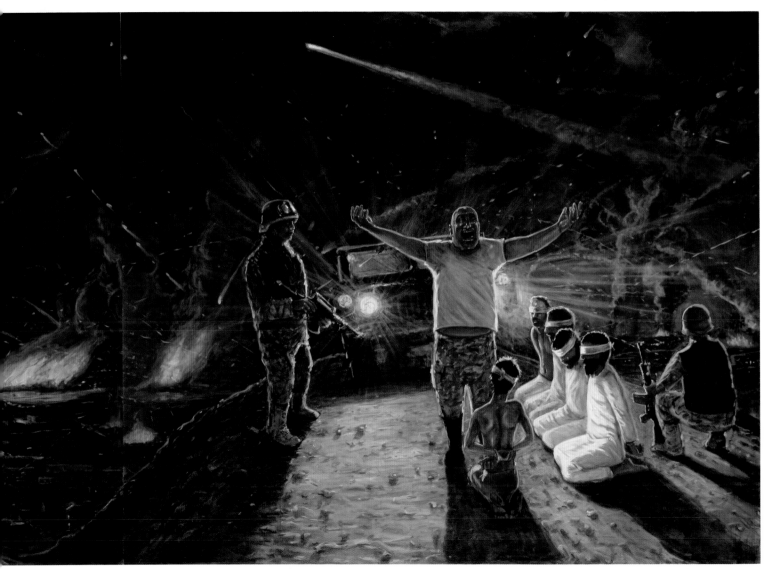

Afterword by Curator Mitchell De Jarnett

It has been a distinct privilege to work with Michael Knowlton on this exhibition. The paintings reproduced on these pages have been brilliantly analyzed by Nathan Spoor, C.R Stecyk, and Jerome Witkin, all of whom I would like to thank for writing under the pressure of the unreasonable deadlines required by this project. I must also acknowledge that this exhibition could not have materialized without the stalwart support of Michael Mitchell, Andrea Lee Harris,

Mike McGee, Greg Escalante, and the board of directors of the Grand Central Forum. To all of you, I extend my deepest thanks. Lastly, while I freely acknowledge the import of Michael Knowlton as a puckish observer of contemporary events, I would like to draw your attention to another, less obvious aspect of his achievement here. For all the power of their subject matter, these works are executed with a technical virtuosity which is both idiosyncratic and voluptuous. Indispensable cultural critic he may be, but Michael Knowlton is also one heck of a hand with a brush and paint.

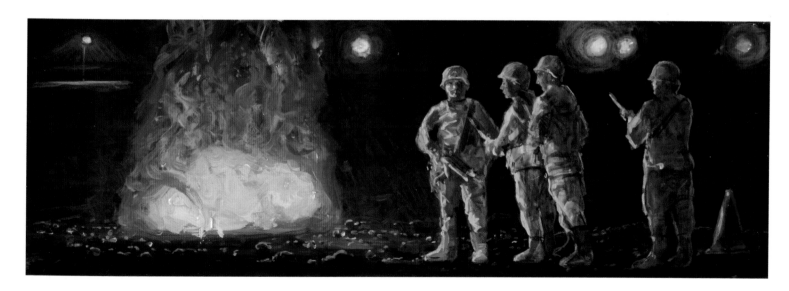

ROADSIDE WATCH
Oil on panel 5" x 14"

"A Viet Nam vet once told me ' It's a glorious, heroic achievement to be a warrior in the defense of a nation as long as it's truly defensive.'
Fighting some wars seemed to me like digging in your finger for a piece of glass that isn't there, realizing it, and continuing to dig." - MK

This book was made possible through a generous
donation from Michael Mitchell, special thanks - MK

The artist wishes to thank the following for their help
and support with this exhibition:

Mitchell De Jarnett
Greg Escalante
Andrea Harris-McGee
Mike McGee
Nathan Spoor
C.R. Stecyk
Jerome Witkin

CALIFORNIA STATE UNIVERSITY FULLERTON
GRAND CENTRAL ART CENTER
Andrea Harris-McGee, Dennis Cubbage, Alyssa Cordova,
Tracey Gayer, Matt Miller, Yevgeniya Mikhailik, Eric Stoner,
David Brokaw, Preston Daniels, Antonio Pedraza
and James Dowdy

GRAND CENTRAL ART FORUM
Greg Escalante, Steve Jones, Mitchell De Jarnett,
Marcus Bastida, Teri Brudnack,Jon Gothold, John Gunnin,
James Hill, Chris Hoff, Mary Ellen Houseal, Dennis Lluy
Mike McGee, Robert Redding, Jon Webb
and Advisory members: Peter Alexander, Rose Apodaca
Jones, Kristine Escalante, Mike Salisbury, Anton Segerstrom,
Shelley Liberto, Stuart Spence and Paul Zaloom

CALIFORNIA STATE UNIVERSITY FULLERTON
President Milton Gordon, Jerry Samuelson, Marilyn Moore
and Bill Dickerson

EXHIBITION DESIGN STUDENTS
Jacqueline Bunge, Rachel E. Chaney, Karen Crews.
Alexandra Duron, Jennifer Frias, Krystal Glasman, Joanna
Grasso, Carlota F. Haider, Sarah Kucklick, Lilia Lamas
Elizabeth Little, Jillian Nakornthap, Michel Oren, Heather
Rose, Johnny Sampson, Lynn Stromick and Elizabeth Tallman

This book has been published by CSUF Grand Central Art
Center and the Grand Central Press in conjunction with the
exhibition *Michael Knowlton - Blackwater Babylon*.
The exhibition was presented at the CSUF Grand Central Art
Center Project Room, Santa Ana, California,
April 5 - May 18, 2008

Curator and Book Designer: Mitchell De Jarrett
Publication and Exhibition Coordinator: Andrea Harris-McGee
Editor: Sue Henger
Photographers: Mark Chamberlain
Printed by: Permanent Printing Limited, Hong Kong, China
First Printing April 2008

GRAND CENTRAL PRESS
CSUF Grand Central Art Center
125 N. Broadway, Santa Ana, California 92701
714-567-7233 714-567-7234
www.grandcentralartcenter.com

International Standard Book Number: 978-0-9771696-8-9